What's So Great About This State?

There is a lot to see and celebrate...just take a look!

CONTENTS

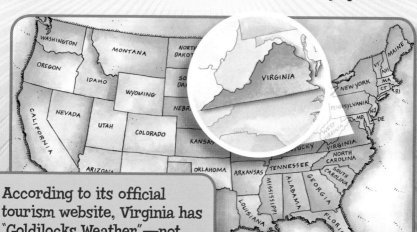

According to its official tourism website, Virginia has "Goldilocks Weather"—not too hot; not too cold. (Which means it's just right!)

Well, how about...
the land!

From the Ocean...

Virginia is a beautiful state on the east coast of the United States, where waves of the Atlantic Ocean and the Chesapeake Bay roll onto the beaches and barrier islands of the state's eastern shore. Here, the land is at sea level—and life often revolves around the changing tides.

Moving further inland, marshy areas soon give way to gently rolling hills. Busy cities as well as acres of farmland and forests cover the interior of the state.

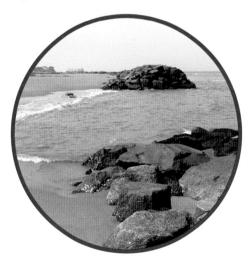

The waves, rocks, and sand along Virginia Beach make it an attractive vacation spot.

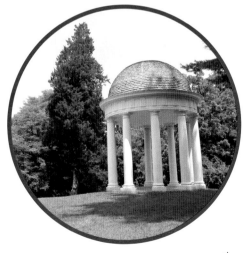

The grounds of Montpelier, once the home of President James Madison, lie in the rolling foothills of Virginia.

Fall leaves bring color to Rock Castle Creek.

...To the Mountains

The beautiful foothills rise up to the Blue Ridge Mountains—part of the eastern range of the huge Appalachian Mountains. Even more rugged turf lies to the west, where tall ridges are cut by deep valleys. In southwestern Virginia a mostly rocky and hilly plateau region is loaded with rich mineral resources

It's quite an adventure to explore the land across Virginia. Take a closer look at the next few pages to see just some of the interesting places you can visit.

The Blue Ridge Parkway meanders through the mountains of Virginia (and North Carolina) for hundreds of miles.

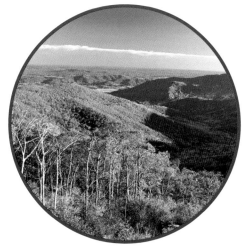

Shenandoah National Park shines with fall colors. The mountains are usually ten degrees cooler than the valleys below.

The Coastal Plain

THE COASTAL PLAIN

A view of the Chesapeake Bay Bridge-Tunnel from the Eastern Shore of Virginia.

The Coastal Plain (or Tidewater) includes part of the mainland coast and a piece of the Delmarva Peninsula. The Delmarva contains the whole state of Delaware but also parts of Maryland and Virginia. (Get it? Del-Mar-Va!) Virginia's part of the Delmarva, called the Eastern Shore, connects to mainland Virginia by the Chesapeake Bay Bridge-Tunnel. This amazing series of bridges and tunnels is more than 17 miles long!

Are there any more peninsulas?

Yes! Besides the Eastern Shore, the northern part of Virginia's Coastal Plain region has three other peninsulas. They formed between the major rivers that flow into the Chesapeake Bay: the Potomac, Rappahannock, York, and James rivers.

What else is special about the Coastal Plain?

The Hampton Roads harbor is one of the best natural harbors in the world. Big cities have sprung up in this area around the busy ports of Norfolk, Newport News, and Portsmouth, where ships transfer millions of tons of products each year.

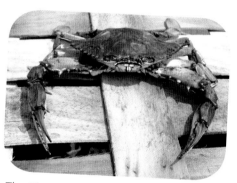

The Chesapeake Bay is famous for its blue crabs.

...then the land gets dismal.

As in the Great Dismal Swamp, that is! This large wetland area lies in the southeastern area of the Coastal Plain region and extends into northeastern North Carolina. Many different plants and animals thrive in this moist and marshy environment. Lake Drummond, a 3,000-acre natural lake, is located in the heart of the swamp.

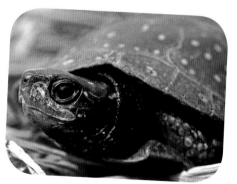

Spotted turtles are common in the Great Dismal Swamp.

Piedmont

The James River flows past Virginia's capital
city, Richmond, which is in the Piedmont region.

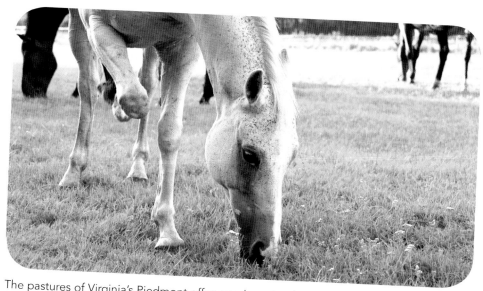
The pastures of Virginia's Piedmont offer good grazing for horses.

The Piedmont region lies just west of Virginia's Fall Line—which is not a real line, of course. The Fall Line is an area where the nature of the land begins to change. Waterfalls and rapids often appear with the changing landscape.

What's so special about the Piedmont?

The Piedmont region has some good farmland that produces such products as corn and tobacco. Thick forests provide lumber. As Virginia's largest region, it also has lots of cities. Richmond and Petersburg developed along the Fall Line. In the northern Piedmont area near Washington, D.C., you can find the cities of Alexandria, Manassas, and Falls Church.

What kind of things can I see in the Piedmont?

You can see beautiful rolling hills, valleys, rivers, and lakes. If you follow the Virginia Birding and Wildlife Trail, you may see many different species of birds. Other critters you might spot in Piedmont forests include white-tailed deer, raccoons, and even bobcats.

Grapes grow well in Piedmont vineyards.

Mountains, Valleys, and Plateaus

VALLEY AND RIDGE

BLUE RIDGE

APPALACHIAN PLATEAU

The Shenandoah River runs through Virginia's Great Valley— part of the Valley and Ridge region.

The western area of Virginia has the most mountains. The Allegheny and Blue Ridge mountains run through this part of the state—with the Shenandoah Valley lying between them.

What's up in the Blue Ridge region?

Just about everything! The Blue Ridge Mountains are part of the eastern Appalachian Mountain Range. The highest mountain in Virginia—Mount Rogers—is in this area. It towers 5,729 feet above sea level.

What's the Valley and Ridge region like?

Just west of the Blue Ridge Mountains, the Valley and Ridge region has long narrow mountains, or ridges, separated by deep river valleys. The Allegheny Mountains and the Great Valley of Virginia are part of this region. The New, Clinch, and Shenandoah rivers flow through the area as well.

...and don't forget the Plateau!

In Virginia's southwest corner lies a small region called the Appalachian Plateau. It's well known for its coal and natural gas deposits. It's also famous for a natural mountain pass called the Cumberland Gap. Long ago, thousands of settlers used this pass as an east-west gateway through the Appalachian Mountains.

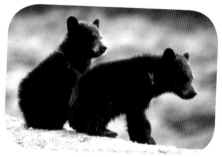

Two black bear cubs play on a log in Shenandoah National Park.

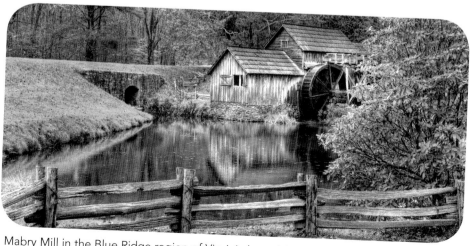

Mabry Mill in the Blue Ridge region of Virginia has a historic gristmill, sawmill, and blacksmith shop.

Well, how about...
the history!

Tell Me a Story!

The story of Virginia begins thousands of years ago. Following the tradition of their ancestors who first lived on the land, American Indians made their homes throughout the state. Different languages were spoken according to where people lived. In the Piedmont region, Siouan languages were used. In the southern and southwestern regions, Iroquoian languages dominated. In the Tidewater region, Algonquian languages were spoken and the powerful Powhatan were part of this group.

When English settlers arrived at the banks of the James River in 1607, conditions were very harsh for them. Luckily, Jamestown colonist Captain John Smith traded with the Powhatans for food. The cooperation between the Powhatans and the colonists was vital for the survival of this first English settlement, called Jamestown.

This statue in Jamestown honors Pocahontas, the daughter of Chief Powhatan. She was just a child when English settlers arrived.

...The Story Continues

Eventually, Virginia became home to other groups of European immigrants (including Scots-Irish and German) and Africans. These groups, along with American Indians, eventually forced big changes between the Virginia colony and England. In the process, many battles for independence were fought. In fact, the first major clash of the Civil War, the first Battle of Bull Run (Manassas) took place in the state.

However, history isn't always about war. Virginians have always been educators and inventors. They have painted, written, sung, and built. Many footprints are stamped into the soul of Virginia's history. You can see proof of this all over the state!

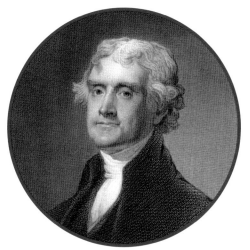

Thomas Jefferson, who was born in Virginia in 1743, was governor of Virginia, the third president of the United States, and the main author of the Declaration of Independence.

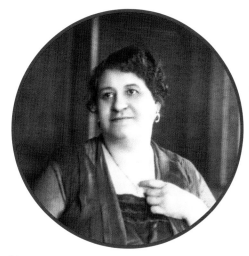

Maggie L. Walker was born in Virginia—her mother was a former slave. In 1903 Walker became the first woman in the United States to start a bank. She worked to support African American causes her whole life.

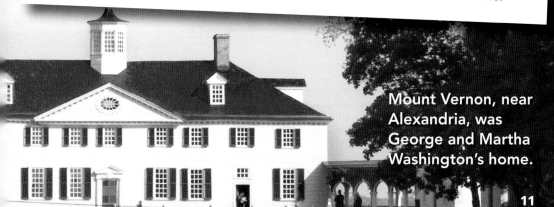

Mount Vernon, near Alexandria, was George and Martha Washington's home.

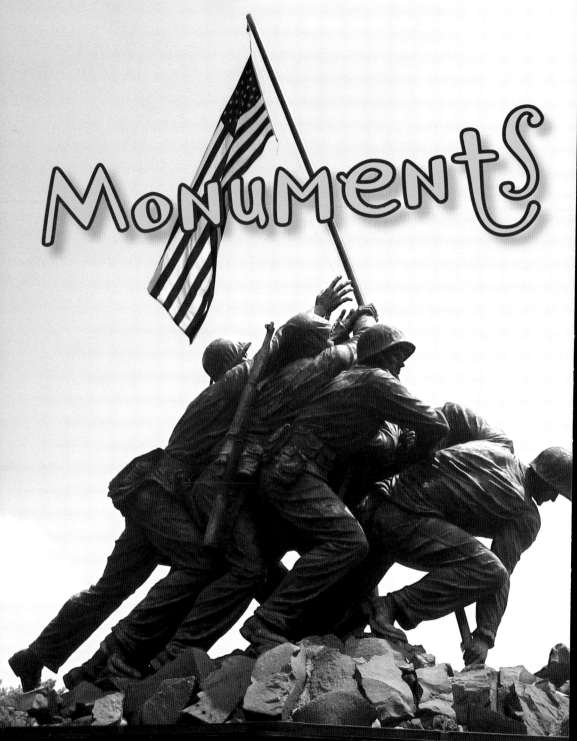

Monuments

REVOLUTIONARY·WAR·1775–1783 × FRENCH·NAVAL·WAR·1798–1801 × TRIPOLI·1801–1805 × WAR

COMMON
VALOR
A COMMON
VIRTUE

The U.S. Marine Corps War Memorial (also called the
Iwo Jima Memorial) is in Arlington, Virginia.

Monuments and memorials honor special people or events. The United States Marine Corps War Memorial was inspired by a real photo taken during one of the most historic battles of World War II.

Why are Virginia monuments so special?

That's an easy one! The monuments honor the many special people who helped build the state. Some were famous soldiers and politicians. Others were just ordinary people who did "extraordinary" things to shape Virginia—and the nation.

What kind of monuments can I see in Virginia?

There are many different kinds. From statues to bridges, almost every town has found some way to honor a historic person or event.

For example, the Monitor-Merrimac Memorial Bridge-Tunnel that connects Newport News with Suffolk honors an important Civil War sea battle that took place in the area. The Confederate ship *Virginia* (rebuilt from a ship called the *Merrimac*) tried to break the Union's blockade at Hampton Roads. Since it was a special ironclad ship, the *Virginia* was at first successful against the wooden-hulled Union ships.

However, when the Union's own ironclad ship (the USS *Monitor*) arrived, the battle changed. Neither ironclad was able to sink the other, so the battle was a draw and the blockade remained. But after this battle new warships around the world were built on the ironclad design!

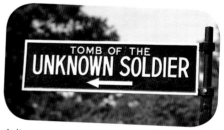

Arlington National Cemetery honors American war heroes and historical figures. Millions of people visit each year. Many pay respect at the Tomb of the Unknown Soldier.

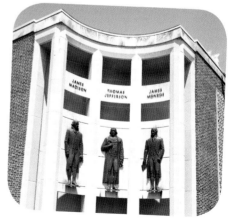

A wall of the Charlottesville City Hall honors James Madison (fourth president of the United States), Thomas Jefferson (third president of the United States), and James Monroe (fifth president of the United States).

MuSeumS

The Appomattox County Historical Museum
is in an old jail building.

The Appomattox County Historical Museum has a special story to tell about the Civil War. On April 9, 1865, in the village of Appomattox Court House, Confederate General Robert E. Lee met with Union General Ulysses S. Grant to surrender the Army of Northern Virginia—which began the process that ended the Civil War.

Why are Virginia's museums so special?

The museums throughout Virginia include amazing exhibits that tell the story of the state. For example, the Living Museum of Virginia showcases the natural history of all regions of Virginia— from the Appalachian Mountains to the Chesapeake Bay. Visitors can even explore Virginia's underground ancient past. A walk-through limestone cave exhibits fossils and colorful gems of an underground mine.

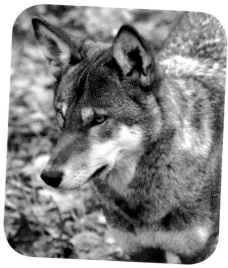

You can see a red wolf like this one— from a safe distance—at the Virginia Living Museum. The museum participates in a federal program to reintroduce the endangered red wolf back into the wild.

What can I see in a museum?

An easier question to answer might be "What can't I see in a museum?" There are thousands of items in different museums across the state. Do you want to see a real moon rock? The Virginia Science Museum in Richmond has one! Or maybe you'd like to learn more about the history of southern Appalachian music? If so, the Mountain Music Museum in Bristol may be for you. And if you want to see sports memorabilia, visit the Virginia Sports Hall of Fame and Museum in Portsmouth.

Pamplin Historical Park is a living history museum that shows what life was like for the common Civil War soldier.

Plantations

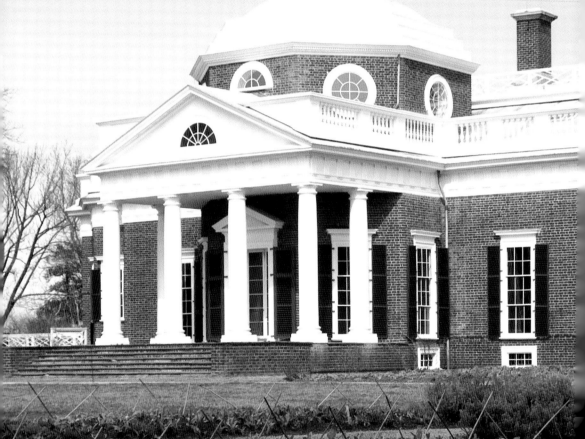

Thomas Jefferson began building his
Monticello plantation in 1769.

Does the Monticello plantation look familiar to you? It should! It's pictured on a coin you use all the time. Starting in 1938, U.S. Jefferson nickels were engraved with Thomas Jefferson on the front—and Monticello on the back.

Why are plantations special? (...and what is a plantation, anyway?)

Plantations were large estates or farms where crops such as wheat, corn, and tobacco were grown. Enslaved Africans, and, later, enslaved African Americans, did most of the work on a plantation.

Today, many plantations tell the shared history of our country. All have fascinating stories of race, culture, families, and sacrifice.

A quill pen was made from a flight feather of a large bird—often a goose.

What can I see if I visit a plantation?

Some plantations show you what life was like hundreds of years ago. Virginia's oldest plantation—the Shirley Plantation—was founded in 1613, just six years after the first permanent English settlement in Jamestown. Today, young visitors to the plantation can find out what school was like in colonial times. They can even use a quill pen and ink!

...and there's more!

A wide variety of birds find habitats at the Berkeley Plantation in Charles City. (This plantation was the birthplace of William Henry Harrison, the ninth president of the United States.) The Berkeley Plantation is now on the Virginia Birding and Wildlife Trail.

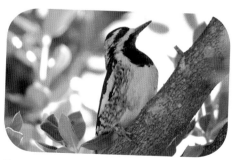

Trees at the Berkeley Plantation make great homes for birds like the yellow-bellied sapsucker, which is a small type of woodpecker.

Well, how about...
the people!

Enjoying the Outdoors

Almost eight million people live in the state of Virginia. Though they have different beliefs and different traditions, Virginians have plenty in common.

Many share a love of the outdoors. With four seasons and a mild climate, people can enjoy a lot of different activities. They might go skiing and sledding in the winter, rafting and hiking in the spring, swimming and golfing in the summer, and camping and biking in the fall. The list of activities that Virginians enjoy goes on and on!

Hiking is popular in Virginia. The views are breathtaking in Shenandoah National Park.

Many people enjoy kayaking, which can be done in the many rivers and lakes throughout the state as well as along the ocean coast.

Sharing Traditions

The people of Virginia understand the value of passing on traditions. Did you ever wonder what life was like in colonial times? The entire town of Colonial Williamsburg dedicates itself to making eighteenth-century history come alive so that current and future generations can learn from the past.

Cooking is another way to pass on traditions. Recipes—from pan-fried oysters to apple tansey—have been cherished family keepsakes for generations. Smoking country hams is also a long-standing tradition in Virginia. And when it comes to peanuts—whether it's growing them, eating them, or cooking with them—Virginia takes top honors.

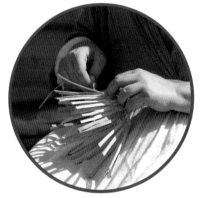

Skilled reenactors at Colonial Williamsburg show how baskets used to be woven by hand.

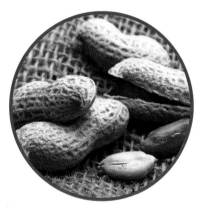

Virginians know peanuts! Millions of pound of peanuts are grown in the state each year.

Beautiful views abound throughout Virginia.

Protecting

Harbor seals visit Virginia's coastal waters in winter and spring.

The Virginia Aquarium and Marine Science Center has a Stranding Response Center. It assists sea turtles and marine mammals—like harbor seals—if they are found sick or injured on beaches. Protecting all of Virginia's natural resources is a full-time job for many people!

Why is it important to protect Virginia's natural resources?

From the sandy beaches of the barrier islands to the dense forests of the mountains, the different environments in Virginia mean that many kinds of plants and animals can live throughout the state. In technical terms, Virginia has great biodiversity! This biodiversity is important to protect because it keeps the environments balanced and healthy.

What kinds of organizations protect these resources?

The state's main environmental agencies are the Department of Game and Inland Fisheries, the Department of Agriculture and Consumer Services, and the Department of Conservation and Recreation. Other state organizations, such as the Virginia Conservation Network and the Natural Heritage Program, also work to conserve, protect, and enhance the state's natural resources.

And don't forget...

You can make a difference, too! It's called "environmental stewardship"—and it means you are willing to take personal responsibility to help protect Virginia's natural resources.

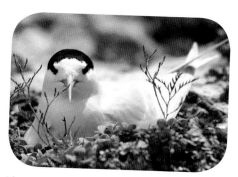

The roseate tern, which nests on barrier islands and salt marshes, is in danger of disappearing from the Virginia coast.

Gray's lily is a delicate plant that is becoming rarer in the higher elevations of Virginia where it naturally grows.

Creating Jobs

The Pentagon is in Arlington, Virginia.

Many federal government jobs are located in Virginia. The Pentagon, headquarters for the U.S. Department of Defense, is one of the world's largest office buildings. (Around 23,000 people work there!) There are also Air Force, Army, Marine, Navy, and Coast Guard facilities in the state.

What other kinds of jobs are in the state?

Virginia has many different industries. Jobs in agriculture are important. Coastal fisheries that bring in such shellfish as oysters and crabs are also a big business. Many people also work in manufacturing—producing chemicals, electrical equipment, food, and beverages. Other jobs can be found in mining coal, stone, sand, and gravel. Jobs in high tech are important, too.

There are a lot of jobs in the service industry. Tourism is a big business in the state and many people—including chefs, waiters, hotel clerks, and others—are needed to help tourists sightsee, eat, and relax!

Don't forget the ships!

Virginia ports have been building and repairing ships for centuries. The Norfolk Naval Shipyard in Portsmouth is currently one of the largest shipyards in the world.

Virginia is one of the top apple-producing states in the country.

High tech jobs are growing in demand.

Skilled workers are needed to build and repair huge ships.

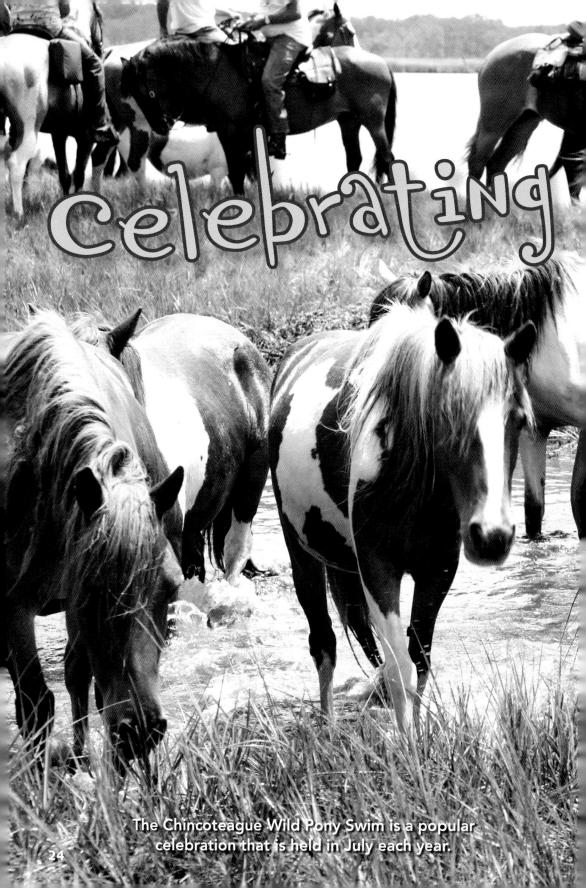

celebrating

The Chincoteague Wild Pony Swim is a popular celebration that is held in July each year.

The people of Virginia really know how to have fun! Each year thousands line up to watch wild ponies make the three-minute swim from Chincoteague National Wildlife Refuge on Assateague Island to Chincoteague Island. The first foal (baby pony) ashore is named King or Queen Neptune, and the Chincoteague Carnival then begins!

Why are Virginia festivals and celebrations special?

Celebrations and festivals bring people together. From cooking contests to art shows, events in every corner of the state showcase different talents.

What kind of celebrations and festivals are held in Virginia?

Too many to count! But one thing is for sure. You can find a celebration or festival for just about anything you want to do.

Do you like traditional county fair food? You can find plenty at the Pork, Peanut, and Pine Festival in Surry. Do you like mountain music? The Old Fiddler's Convention in Galax gathers musicians who play tunes that have been handed down for generations.

You can try your hand at pottery making at the Sugarloaf Craft Festival in Chantilly.

...and don't forget the Ramp Eating Contest!

At the Whitetop Mountain Ramp Festival people gather to enjoy mountain music, crafts, games, dancing, and the Ramp Eating Contest! What's a ramp? It's a wild onion that tastes like garlic and onion combined. (Breath mints are optional!)

Foot-tapping music is played in the Blue Ridge Mountains.

Birds and Words

What do all the people of Virginia have in common? These symbols represent the state's shared history and natural resources.

State Bird
Cardinal

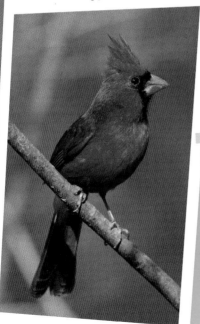

State Flower
American Dogwood

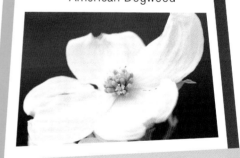

State Tree
American Dogwood

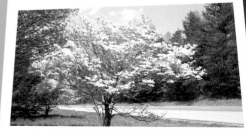

Virginia uses the same plant for its state tree and its state flower!

State Fish
Brook Trout

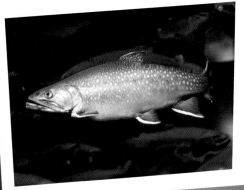

State Flag

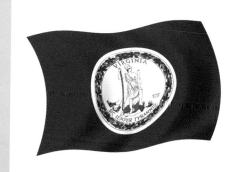

State Butterfly
Eastern Tiger Swallowtail

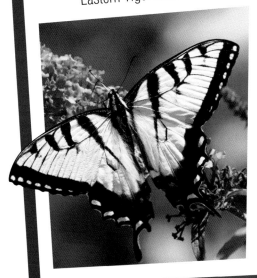

State Beverage
Milk

Want More?

Statehood—June 25, 1788
State Capital—Richmond
State Bat—Virginia Big-Eared Bat

State Folk Dance—Square Dance
State Motto—"*Sic semper tyrannis.*" ("Thus always to tyrants.")

More Fun Facts

More
Here's some more interesting stuff about Virginia.

A Capital Idea
Virginia has had three capital cities: **Jamestown**, **Williamsburg**, and **Richmond**.

"Give Me Liberty . . ."
Patrick Henry made his famous speech in St. John's Church in **Richmond**.

"On Your Mark, Get Set . . ."
A plaque at Monticello symbolizes the starting place in 1803 of the Lewis and Clark Expedition.

Whose Side Are You On?
Depending on which side of State Street you stand on, you could be in **Bristol**, Virginia, or Bristol, Tennessee!

By Common Consent
When the first Constitution of Virginia was adopted in 1776, delegates used the term "Commonwealth of Virginia" (rather than "State of Virginia") to name the new form of government.

Birthplace of Presidents
Eight U.S. presidents were born in Virginia: George Washington, Thomas Jefferson, James Madison, James Monroe, William Henry Harrison, John Tyler, Zachary Taylor, and Woodrow Wilson.

Presidential Pets
The Presidential Pet Museum in **Williamsburg** highlights past and current White House pets, from George Washington's horse, Nelson, to the Obama family's Portuguese water dog, Bo.

Underground Classroom

Since its discovery in 1878, Luray Caverns in the Shenandoah Valley has become one of the most visited caves in the eastern United States.

On A Clear Day . . .

Five states can be seen from the 100-foot-tall Big Walker Lookout in the Appalachian Mountains near **Wytheville**.

Ham It Up

The world's oldest edible cured ham is more than 105 years old and is on display at The Isle of Wright Museum in **Smithfield**!

Mountain Music Road

The Crooked Road: Virginia's Music Heritage Trail winds for more than 300 miles through the mountains of southwest Virginia, connecting different places that play great traditional music.

Dead Center

The geographic center of Virginia is in Buckingham County, 5 miles southwest of **Buckingham**.

New Beginnings

Virginia was the site of the surrenders ending the American Revolution (**Yorktown**) and the Civil War (**Appomattox**).

The First by the First

At age 17, George Washington helped lay out the town of **Washington**, Virginia—making it "the first Washington of all."

As Strong as an Oak

In 1863 President Lincoln's Emancipation Proclamation was read under an oak tree in **Hampton**. The tree, now known as the Emancipation Oak, still stands.

A Shining Star

The huge Mill Mountain Star, constructed at the top of Mill Mountain in 1949, gave **Roanoke** its nickname of "Star City."

King of the Beaches

Virginia Beach (the state's largest city) has miles of beaches. The King Neptune statue at the Boardwalk on 31st Street is 34 feet high.

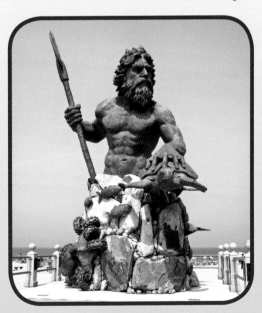

Anchors Aweigh!

Norfolk is home to the world's largest naval station.

Find Out More

There are many great websites that can give you more information about the exciting things that are going on in the state of Virginia!

State Websites

The Official Website of Virginia
www.virginia.gov

Virginia State Parks
www.dcr.virginia.gov/state_parks/

The Official Travel and Tourism Site of Virginia
www.virginia.org

Museums/Arlington

The Arlington Arts Center
www.arlingtonartscenter.org

Danville

Danville Science Center
www.dsc.smv.org

Harrisonburg

The Virginia Quilt Museum
www.vaquiltmuseum.org

Lynchburg

The Lynchburg Museum
www.lynchburgmuseum.org

Manassas

The Manassas Museum
www.manassascity.org

Martinsville

The Virginia Museum of Natural History
www.vmnh.net

Newport News

The Virginia Living Museum
www.thevlm.org

Richmond

Black History Museum and Cultural Center of Virginia
www.blackhistorymuseum.org

The Museum of the Confederacy
www.moc.org

Science Museum of Virginia
www.smv.org

Roanoke

History Museum of Western Virginia
www.history-museum.org

Aquarium and Zoos

Virginia Aquarium & Marine Science Center
www.virginiaaquarium.com

The Virginia Zoo in Norfolk
www.virginiazoo.org

The Mill Mountain Zoo (Roanoke)
www.mmzoo.org

Virginia: At A Glance

State Capital: Richmond

Virginia Borders: Washington, D.C.; Maryland, North Carolina, Tennessee, West Virginia, Kentucky, and the Atlantic Ocean

Population: almost 8 million

Highest Point: Mount Rogers; 5,729 feet above sea level

Lowest Point: sea level at the Atlantic Ocean

Some Major Cities: Virginia Beach, Norfolk, Chesapeake, Richmond, Newport News, Alexandria, Roanoke

Some Famous Virginians

Robert E. Lee (1807–1870) from Westmoreland County; was the commanding general of the Confederate Army of Northern Virginia.

Shirley MacLaine (born 1934) from Richmond; is a film and theater actress, dancer, and author.

Cyrus McCormick (1809–1884) from Rockbridge County; was the inventor of the reaper and founded what is today the International Harvester Company.

Booker T. Washington (1856–1915) from Franklin County; was an educator, lecturer, author, and political leader.

Ella Fitzgerald (1917–1996) from Newport News; was a Grammy Award–winning jazz and song vocalist.

Pocahontas (1595–1617) was Virginia Indian Chief Powhatan's daughter who helped colonial settlers at Jamestown.

Willa Cather (1873–1947) from Back Creek Valley; was a Pulitzer Prize–winning novelist.

John Smith (1580–1631) from Willoughby, England; was an English soldier and explorer who established the first permanent English settlement in North America at Jamestown.

Patsy Cline (1932–1963) from Winchester; was a country music singer.

Katie Couric (born 1957) from Arlington; is a journalist and the first solo female anchor of a weekday evening television news program.

L. Douglas Wilder (born 1931) from Richmond; is a politician and the first elected African American governor in U.S. history.

Patrick Henry (1736–1799) from Hanover; patriot leader who is best remembered for his "Give me liberty, or give me death" speech.

(Please see page 28 for eight famous presidents, too!)

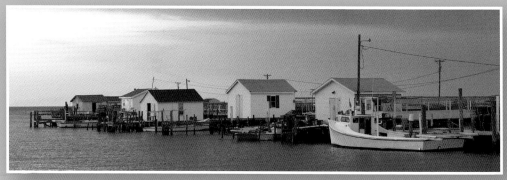

Dawn on Tangier Island

CREDITS

Series Concept and Development
Kate Boehm Jerome

Design
Steve Curtis Design, Inc. (www.SCDchicago.com); Roger Radtke, Todd Nossek

Reviewers and Contributors
Content review: William B. Obrochta, Virginia Historical Society; Contributing writers/editors: Terry B. Flohr, Stacey L. Klaman; Research and production: Judy Elgin Jensen; Copy editor: Mary L. Heaton

Photography

Back Cover(a), 29a © MAWHYYOUARE/Shutterstock; Back Cover(b) © Andrey Yushkov/Shutterstock; Back Cover(c), 10a by Lee Braverman; Back Cover(d), 3b © S.Borisov/ Shutterstock; Back Cover(e), 7a © scyther5/Shutterstock; Cover(a) © Olga Bogatyrenko/Shutterstock; Cover(b), 26c © H Peter Weber/iStockphoto; Cover(c), 5a © APaterson/ Shutterstock; Cover(d), 16-17 © Mermozine/Shutterstock; Cover(e), 2a © Becky Hayes/Shutterstock; Cover(f) © Dave Newman/Shutterstock; 2-3 © Darren K. Fisher/Shutterstock; 2b © Jeffrey M. Frank/Shutterstock; 3a © Robert Donovan/Shutterstock; 4-5 © Joseph C. Justice Jr./iStockphoto; 5b © Ryan M. Bolton/Shutterstock; 6-7 © Heath Oldham/ Shutterstock; 7b © lillisphotography/iStockphoto; 8-9, 21b, 26b © Mary Terriberry/Shutterstock; 9a © National Park Service Photo; 9b © Judy Kennamer/Shutterstock; 10-11 © Joel Shawn/Shutterstock; 11a © Steven Wynn/Shutterstock; 11b Courtesy National Park Service, Maggie L. Walker National Historic Site; 12-13 by Wally Gobetz; 13a © Rob Wilson/ Shutterstock; 13b © Joe Potato Photo/iStockphoto; 14-15 Courtesy TourAppomattox.com; 15a By Dave Pape/from Wikimedia; 15b Courtesy Pamplin Historical Park, Dinwiddie County, VA; 17a © Studio 37/Shutterstock; 17b © Donna Heatfield/Shutterstock; 18-19 © John Keith/Shutterstock; 18a © Sven Klaschik/iStockphoto; 18b © iofoto/Shutterstock; 19a © Amy Riley/iStockphoto; 19b © Maksymilian Skolik/Shutterstock; 20-21 © Peter Wey/Shutterstock; 21a © Gary Unwin/Shutterstock; 22-23 © Frontpage/Shutterstock; 23a © msheldrake/ Shutterstock; 23b © Richard Harvey/Shutterstock; 23c © Glen Jones/Shutterstock; 24-25 By Cory Grace; 25a © Liliya Kulianionak/Shutterstock; 25b © Lynn Watson/Shutterstock; 26a © Doug Lemke/Shutterstock; 27a By Eric Engbretson/US Fish & Wildlife Service; 27b © Pakmor/Shutterstock; 27c © Elizabeth Spencer/Shutterstock; 27d © Madlen/Shutterstock; 28 © pandapaw/Shutterstock; 29b © Christopher Eng-Wong Photography/Shutterstock; 31 © R. Gino Santa Maria/Shutterstock; 32 © David Kay/Shutterstock

Illustration
Back Cover, 1, 4, 6 © Jennifer Thermes/Photodisc/Getty Images

ISBN 978-1-58973-018-2
Library of Congress Catalog Card Number: 2010935883

1 2 3 4 5 6 WPC 15 14 13 12 11 10

Published by Arcadia Publishing, Charleston, SC
For all general information contact Arcadia Publishing at:
Telephone 843-853-2070
Fax 843-853-0044
Email sales@arcadiapublishing.com
For Customer Service and Orders:
Toll Free 1-888-313-2665

Visit us on the Internet at www.arcadiapublishing.com